EGGS BEAUTIFUL
How to Make Ukrainian Easter Eggs

EGGS BEAUTIFUL

How to Make
Ukrainian Easter Eggs

by Johanna Luciow

Ann Kmit

and

Loretta Luciow

Ukrainian Gift Shop • 2422 Central Avenue, N.E.
Minneapolis, Minnesota 55418

© Copyright 1975 by *Johanna Luciow, Loretta Luciow*, and *Ann Kmit*.
All rights reserved. Printed in the United States of America
at Gopher State Litho, Minneapolis, Minnesota.

Library of Congress Catalog Card Number: 75-638
ISBN Number: 0-9602502-3-9

First Printing, 1975
Second Printing, 1976
Third Printing, 1984
Fourth Printing, 1987

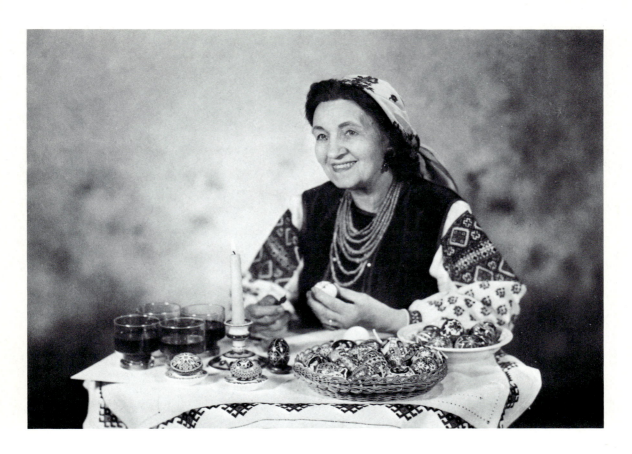

This book is dedicated to our grandmother, Marie Procai, who taught us to decorate eggs as she was taught by her grandmother many years ago in Ukraine. She has set a good example to our family and to our community and has imparted the belief that this Ukrainian art should be kept as a living, growing tradition. Without her help, we would be less rich in the knowledge and the joy of our art.

Acknowledgments

We have quoted from the writing of our late father, Theodore Luciow, whose articles concerning the Ukrainian Easter were published many times and in many places.

We wish to thank the following people for their assistance in producing this book. Without their help, it would have been impossible to produce it successfully.

To Mrs. Marie Procai and Mrs. Luba Perchyshyn for their assistance in supplying references; to Venetia Newall for the boundless source of information on legends and history found in her book, *An Egg at Easter,* published in 1972, by the Indiana University Press. A thank you to Dr. A. Granovsky who offered valuable advice on legends; to Robert Taylor, our patient editor and designer, who helped us put it all together; to Michael Liebig who took the photograph of Marie Procai, and especially to Charles Keeler who took the rest of the photographs.

We also wish to thank the members of our families whose patience and cooperation has been most helpful during the time we have spent gathering information and making preparations for this book.

Table of Contents

EGGS BEAUTIFUL
How to Make Ukrainian Easter Eggs

Introduction

Sparkling colors burst forth from the decorated shell of a Ukrainian egg in a miracle of beauty.

Well over 2000 years ago, before the time of Christ, people were carrying on the custom of decorating eggs. In creating these delicate treasures, the peasant folk were influenced by the belief that great power is embodied in the egg and they decorated eggs in the spring to celebrate the warming of the sun as it brought new joy and vigor to life.

The tradition of decorating eggs has been passed on to us today through strong family ties here in Minneapolis, Minnesota. Our grandmother, Marie Procai, learned this art as a child, around the turn of the century, from her ancestors in Ukraine and taught it to us. Easter egg decorating has been a part of our lives from childhood.

When we became old enough we demonstrated the art, which grandmother had taught us, for many years at the Minnesota State Fair and we have also taught egg decorating to various groups of children and adults.

Our family was featured in an article about Ukrainian Easter Eggs in the *National Geographic* Magazine of April 1972. There have also been numerous other articles in magazines and newspapers, including one in the photo magazine section of the Sunday *Minneapolis Tribune*, dated april 2, 1972, in which color photographs of our eggs were featured. Johanna Luciow, our mother, operates the *Ukrainian Gift Shop* with her mother, Marie Procai, and her sister, Luba Perchyshyn. Together they have created a successful

business where Ukrainians, as well as Americans of other national origins, come from many distant places to purchase handmade eggs, ceramics, and other folk art.

With the increasing popularity of Ukrainian Easter Egg decorating, we thought that a book answering the basic questions of design and coloring should be written. Today, this art can be learned and enjoyed by many people, old and young alike, and it is in the spirit of sharing that this book has been written. In these quickly changing times, it is our hope that the tradition will be kept alive and growing.

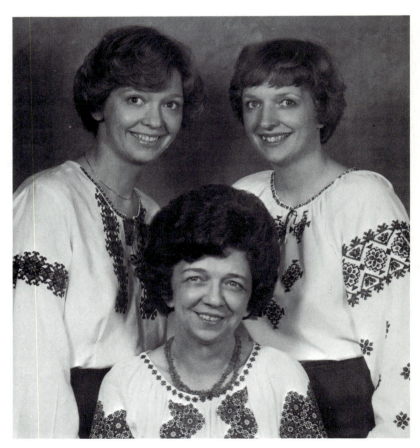

The authors:
Loretta Luciow,
Johanna Luciow,
and Ann Kmit.

The Legends

For years the legends concerning the eggs were communicated verbally from one generation to the next and many of them have been forgotton or lost because they were not recorded. However, we have collected some of the remaining legends concerning pagan and Christian beliefs from various sources and have recorded them here. They are enchanting in their simple beliefs in nature and a higher power.

Pagan Beliefs

It was thought in ancient times that the silent universe suddenly burst forth into human activity and life. In like manner, the egg which also seems dormant and quiet, brings forth life in a triumphant way. Because of the symbolism represented in the egg it became an object to be honored and it was decorated to celebrate the renewal of nature and life. Spring was the logical season for celebration since the cold, dark winter was past, the sun warmed the soil again, and life was no longer such a constant struggle. What a welcome change!

There were spring festivities then. Eggs were dyed in two or three colors in the same wax resist process that is used today.

The eggs were believed to contain great powers; for example, if a woman was barren and desired a child, she would be presented an egg decorated with the design of a chicken, a very fertile creature and hopefully, her family would grow.

Another example of belief in the power of the egg concerned protection from fire. Houses were constructed mainly of wood and often water was obtainable only from wells and far away streams. Fire was an extremely serious prospect then and families could lose every thing they owned. The people believed that if a blaze did start, an egg carried around the area of the blaze would keep it from spreading any further. Sometimes egg shells were thrown into the fire in the belief that they could quench the flames.

A bowl of decorated eggs was often kept in the home in the belief that they would keep the family healthy. The peasants felt that eggs could control the weather and provide food in times of famine as well. Evil spirits were powerless to do their mischief when people used these treasured eggs to help them. Great love and pride went into their decoration and distribution.

Ukrainian women prepared two different kinds of eggs, much as they still do today. The *krashanka* are the boiled edible eggs dyed in one brilliant color, the root word *kraska* means (color). The *pysanky* are the raw multi-colored eggs which are intended as ornaments to be kept indefinitely. The root word *pysaty* means (to write).

For coloring the egg, the decorators prepared colors themselves. Yellow was made from the bark of the wild apple, the onion skin, buckwheat husks, campion, and also from the flower of lilac or dog's fennel. Red was made from the cochineal (carmine), deer horn, the brazoliia (sandalwood or aniline). Green was usually obtained from a concoction of sunflower seeds and berries of the wild elder;

the dark red from black holly-hock, bush-anemones, as well as from leaves of the birch and from moss. For the dark yellow color, alder buds were used along with hazel and chestnut leaves or walnut, apple, and oak bark. Black was prepared from the husks of sunflower seeds by the addition of sulphate of iron, *kupervas,* the bark of the alder, young leaves of the black maple, and sometimes two or three dark periwinkles.

The eggs were prepared and decorated mainly for spring festivals which honored the sun, for it was the sun which warmed the soil so that wheat and other foods could grow. The sun renewed life everywhere and brought light to the dark forests and steppes. The sun was freely represented in the earliest designs.

Christian Beliefs

With the introduction of Christianity to Ukraine in 988 A.D., the "sun" became the "Son" and the ancient customs were absorbed into the Christian celebration of Christ's resurrection. On Easter the triangle designs on the eggs which had represented air, fire, and water now became the symbols for the Father, Son, and Holy Spirit. The old supernatural powers in the decorated eggs were gradually attributed to almighty God. The new meanings blended so harmoniously with the old that even today the mixture of pagan and Christian symbolism can be seen in the designs.

The krashanka figured prominently in the old Ukrainian stories about the *Blazhenni.* In Galicia, these (spirits) were called the *Rakhame* and the *Rochman* in Bukowina. They were the (kindly ones), worthy beings who lived, far away to

the south, on the banks of a river which was fed by all the streams of the world. The Blazhenni inhabited a never-never land beyond the distant waters, on the edges of the earth, variously known as Saturday River and Sunday Water. A lost race, weak and worthy and beloved by God, they were said by some to be the souls of children who died before their baptism, dwelling where they could never see the sun. They knew nothing of the world of men and so at Easter time the women, who celebrate their festival, threw red krashanky egg shells into the streams. The flowing waters carried the tokens away to that distant land, bringing back the message that Easter had been celebrated, so that the Blazhenni could observe the festival themselves.

The Blazhenni were said to lead a holy life and to eat no meat, except on the day when they celebrated Easter, and this was the day when the red egg shells reached them. This feast day was on the second Monday after Easter, except in Bukowina, where the Blazhenni received their Easter eggshells after a period of forty days. Behind the beliefs in this mysterious cult lies the deep grief of bereaved mothers. In a time of high infant mortality, mothers somehow felt relieved that the souls of their children were dwelling in a safe loving place.

Longing for the little dead children became confused with primitive ideas of sun renewal, for the Blazhenni lived in darkness and never saw the daylight. After winter, when the sun's rays were still weak, rituals were common to invoke it to renew its full strength and power. This curious link between red eggs and the souls of little children who died young runs throughout the legends.

Another legend concerning death dealt with the hard cooked krashanka. After the burial of a loved one, a simple colored egg was placed in the loose soil over the grave and left until the next day. If the family returned and found the

egg unblemished and intact, they knew the soul had been accepted and was safe in heaven. If there were marks on the egg, or if an animal had taken it during the night, then certainly the departed one needed assistance from his family, including many prayers.

After the introduction of Christianity to Ukraine, the symbol of the fish became popular on the decorated eggs. The Greek alphabet spells out the word "fish" from "Jesus Christ Son of God Savior (ICHTHYS)". It was the sign of recognition among early Christians. The fish symbol was used in egg decoration by the Ukrainian peasants who kept decorated eggs in their homes and barns.

There are several beautiful legends associated with the Blessed Virgin Mary. The Hutzuls of the western Ukraine tell the story that Mary filled her apron with eggs, and when she appeared before Pontius Pilate to plead for her Son, she dropped to her knees and the eggs rolled out over the surface of the world until they were distributed among all nations.

The spots which the Hutzuls like to include in their motifs represent the tears of the Blessed Virgin Mary, who gave eggs to the soldiers at the cross. As she begged them to be less cruel, she wept, and the drops fell on the shells, spotting them with brilliant dots of color.

In still another tale, Mary is said to have filled a basket with eggs which she carried to the soldiers sitting at the foot of the cross. There she left it. After a time, the blood of our Lord flowed down, as in early art it flows over Adam's skull, in token of man's redemption, staining the eggs with their characteristic color. The mystic price of blood money has been paid.

Mary Magdaline, another beloved woman from the Bible, took a basket full of eggs to the sepulchre intending to eat them while she worked annointing the body of Christ. But

no sooner had she arrived, than the eggs were all miraculously changed, their shells stained with brilliant hues. A similar story is told about Simon of Cyrene, transformed by folk imagination into an egg merchant, who was paid for his good deed in helping to carry the cross to Calvary by having all his wares beautifully colored forever after.

Another Hutzul tale has the answer to the problems of the world! According to this tale it is believed that the fate of the world depends upon the pysanka; that as long as the pysanka tradition remains, and eggs continue to be decorated, the world will exist. Should the custom cease, evil will, encompass and destroy the world, because an ancient, vicious creature lies heavily chained against a huge cliff and each year advocates of the creature encircle the earth to keep a record of the number of pysanky decorated. When there are few decorated eggs the creatures chains loosen and evil begins to flow throughout the world. However, should these advocates find the custom of decorating eggs practised extensively, the chains of the monster tighten, allowing love to conquer evil.

Ukrainian krashanky were supposed to remove sickness by transferrence. In serious illness an egg, blessed on Easter eve, was hung around the neck upon a string and the disease was passed into it. A krashanka could also be used to stop blood poisoning; the patient needed only to be touched by the egg.

The farmers' traditions were indeed interesting, for the Ukrainian people were mostly farmers and depended on nature for all of their riches. For example, farmers had a custom of rolling an egg in green oats and then burying it in the field. This would insure a bountiful crop. If a farmer kept bees, he would place an egg beneath the hive. An egg was used to bring forth a bountiful harvest since it was believed

that an egg kept the land and the crops protected from harm. Another belief was that the crops were protected by placing an egg decorated with a wheat design at the beginning of the first furrow when ploughing began and placing another at the end of the last furrow. Thereby, the opening and the closing of the season was marked and blessed.

The designs which were used generally had significant meanings both to the creator of the egg and to the person who received it. If a man wished to have children and his wife had already received an egg with the symbol of a chicken then it was thought that it was his fault if she did not conceive. To help a man conceive children he was given an egg with a pattern of roosters. To assist an older man, whose vigor was waning, an egg was given decorated with oak leaves; both roosters and oak leaves being common symbols of virility.

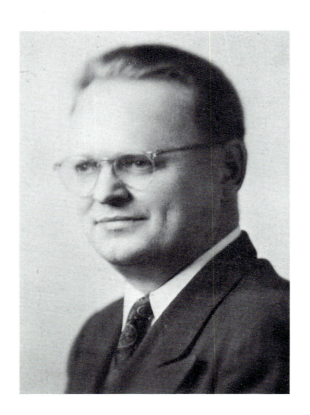

Our father, Theodore Luciow was born in western Ukraine in the village of Buchach. He came to the United States before World War II and served in the U. S. Army. He received his M.A. degree in Education from the University of Minnesota and lived in Minneapolis with his wife Johanna and four children, Ann, Loretta, Theodore Jr. and Anthony until his death in 1969. He enjoyed writing about his boyhood memories. The following selection was titled "Easter Red Letter Day of Year in Ukraine" from the *Tacoma* (Washington) *Sunday Ledger-News Tribune*, April 22, 1962.

Ukrainian Easter Customs

The Easter customs which the Ukrainian people enjoyed are rich in heritage. Their love of beauty can be seen in their hand embroidered clothes, in their folk songs, and in their beautifully decorated houses. This love of beauty permeated the rich religious holy period as well. For Easter is not a three day period but a cycle of forty days when their age old associations with man and nature comes to a religious climax in the resurrection of Christ.

Both the inside and outside of the family home was carefully whitewashed during Lent. The inside walls were often painted with colorful designs, especially in the kitchen area where the family spent much of their time. Everything in the house was dusted and scrubbed and garments were aired and cleaned. If possible, the family was outfitted with new suits and shoes. Since newly baptized Christians in the early centuries wore garments of new white linen it became a tradition for the faithful to wear new clothes to symbolize the "new life" bestowed by the Lord through his resurrection. One must look his best for the coming festive occasion.

Food was prepared differently during lent. Meat and animal fats were not to be eaten for the entire forty days. Milk, cheese, and oils were restricted for seven days before Easter Sunday. During Lent there were special church services, known as hours of recollection, in order that people would be prepared for Easter confession and the

receiving of Holy Communion. No one, after all, would dare to sit at the Easter dinner table and partake of the blessed krashanka and other food without first cleansing himself of his sins by going to confession and receiving Holy Communion.

One Wednesday in the middle of Lent was marked with special church services called *Christopoklonna Sereda* in Ukrainian, or, in a free translation, (Bowing to Christ Wednesday). The congregation would fall to their knees and prostrate themselves before the altar. This was easy to do since there were usually no pews in the church. This act of reverence was repeated hundreds of times during Lent.

Holy Week started with Palm Sunday, the triumphant entrance of Jesus into Jerusalem. In Ukraine, a single pussy willow branch is carried, and friends who met by chance tapped one another with it saying: "Not I that strike thee, but the willow". On Monday and Tuesday of Holy Week the household was kept busy preparing food for Easter.

The passion service was held on Maundy Thursday. It was a long and very sad service. The celebrant would read the parts from the holy scriptures pertaining to the sufferings and the passion of our Lord. His voice, filled with emotion and sorrow, would speak of the tragedy of Jesus, His betrayal, trial and crucifixion. The congregation literally

relived the hours of sorrow listening patiently. Red eggs were prepared this day in great reverence for departed souls.

On Good Friday, which is called the (Passion Friday), *Strastna Pyatnicia* in Ukrainian, the burial service and the procession with the Holy Shroud were observed. In the procession an unframed canvass oil painting depicting Christs' body in the tomb was displayed. Each church had such a painting which was called the "Plaschanytsia", the Holy Shroud. On Saturday the adoration of the Holy Shroud would take place. The custom was to visit all the churches and pray at every tomb so prepared. It was not unusual for a congregation to walk fifteen miles to visit five churches in an area.

On Saturday night all returned to witness the resurrection services. Hundreds of people dressed in their finest clothes would gather around the outside of the church, their faces turned towards the main entrance. The door was closed to signify the sealed tomb of Christ and, before it, stood the clergy. They were dressed in bright gold vestments and carried service books and small crosses in their hands. The main celebrant, the Archimandrite, held a large golden cross. He chanted, "Christ is Risen", "Christos Voskres", three times, each time the words were repeated by the choir and the congregation as he knocked with his cross at the closed door which, at a given moment, opened. This moment signifies the opening of Christ's tomb and His resurrection.

After this, the service of the resurrection would continue inside the church and would last two hours. The main chant of the service was a victorious "Christ is risen from the dead". By His death, He conquered death and to those in the grave, he granted life.

From Easter day to Ascension it was customary to greet people with *Christos Voskrese!* (Christ is Risen), to which one would answer, *Voistynu Voskres!*, (He is Risen Indeed!)

After the mass, pysanky were commonly exchanged as the people greeted one another. Ukrainians intended any gift of decorated eggs, whether large or small, as a sign of fondness for a person. They also embraced and kissed each other on the cheeks three times. This was a warm time of friendship, and even forgiveness; for even those who had not been speaking to each other because of an argument must greet and embrace. The new season started with a spiritual as well as a physical house cleaning. Hutzuls, the mountain dwellers, made it a communal occasion. Everyone gathered in front of the church on Easter day with food for the priest to bless, offering one another colored eggs and begging forgiveness for past wrongs. Later on, boys tried to snatch these eggs from the girls. If a girl made a gift of an egg to a boy, it showed how much she cared for him.

Each family brought a basket to be blessed by the priest on Easter morning following the resurrection services. Depending on the time schedules, this could sometimes be as early as two a.m. The baskets would usually contain a paska, a rich round bread with elaborate dough ornaments, several hard boiled colorful krashanky, one or two psyanky, ham, sausage, cheese, small containers of butter, salt, and grated horseradish. The horseradish was included to remind the people of Christ's bitter ordeal before his death. Covering the basket would be mother's most beautiful embroidered cloth. In good weather the baskets were arranged in a circle around the outside of church. The cloth was set aside and the candle in each basket was lit to signify new life; How they flickered in the cool spring mornings. The tired but happy parishioners would wait for the priest to sprinkle Holy Water on the beautiful array of foods, then home for a good rest. Later the family gathered around the table to break the long strict fast, Grandfather would cut a boiled krashanka into pieces. As he ate a piece, he would extend the ''Kristos

Voskres" greeting to his family, friends, and neighbors. Everyone would partake of a piece of this egg. A portion of the egg would even be sent to family, friends, and neighbors who were not present.

On Easter Monday, the old custom has been to sprinkle water on everyone. This custom comes from the pre-Christian era when the people "washed their diseased and bad spirits away". Easter Tuesday was spent in the local churchyard where the cemetery was located. Church bells rang joyfully all during the day. The people would fill the cemetery and each family would gather at the grave of their loved ones, kneeling and praying and often asking the priest to say a special prayer for the departed souls. It was believed that anyone dying during the Easter season would go to heaven.

As the older people prayed and visited the graves, the younger set enjoyed the *hahilky*, traditional spring games

and songs. The *hahilky* contained many elements of round dances and mimicry closely combined with interpretive song, and their themes were mostly concerned with the welcoming of the sun, the burial of winter, and calling upon the forces of nature.

Like many other traditional spring rituals, the *hahilky* dates back to pagan times when our ancestors worshipped nature and sought to appease nature's gods.

In later times the *hahilky* began to incorporate many pantomine scenes from Ukrainian history, such as the Tatar attacks, and the expeditions of the Ukrainian forces.

One of the games the youngsters enjoyed was when the pointed tip of an egg was tapped against an opponent's egg and the winner holding the unbroken egg kept the spoils. Indeed, the entire community celebrated Easter Sunday with pleasure and good will!

Oblivany ponedilok or (Sprinkled Monday), so called because of the custom among young men and women to (Sprinkle) each other with water, was an old tradition dating back to the pagan worship of water as the life giving element. In those days a bath, taken in the spring, symbolized an emergence from winter's spiritual (imprisonment).

Ukrainian Symbols and Designs

The smooth, symmetrical shape of the egg lends itself to the beautiful patterns which have developed over the centuries. The Pysanky were exchanged on Easter morning between friends and relatives, much as valentines are given as tokens of love today. If, for example, a friend was a farmer, he might be presented with an egg decorated with shafts of wheat wishing him a bountiful harvest. There might also be rakes and other tools incorporated into the design. These would signify the "wish" for him to practice the art of farming with success.

Young married couples would often be presented with an egg decorated with a chicken design. Since the chicken is a symbol of fertility, it was hoped that the family would grow in number.

Since the "wishes" would vary from one year to another and from one egg to another, the design would develop into an ever-changing combination of color and motifs. It is somewhat difficult to say that the sun always meant "good luck". Sometimes it did, but it also represented life, warmth, and growth. Often it depended on the idea in the egg-maker's mind, or even the region of Ukraine from which he came, for its true meaning.

We have collected a sampling of some of the patterns which are popular. Pysanky designs are usually intended to suggest a thing rather than to picture it exactly. They fall into three general categories: plant, animal, and geometrical. This list is by no means complete!

There is such an infinite variety of designs from the different regions of Ukraine that an entire volume of several hundred pages could be devoted to their origins. We have

29

made no attempt to categorize the patterns, but just to give a tempting sample of the variety and beauty possible.

We would like to mention also, that a very recent but popular development in decorating eggs has been to "personalize" them by incorporating a "Happy Easter to Grandpa 1975" into the border of the designs. Some people prefer to collect dated eggs.

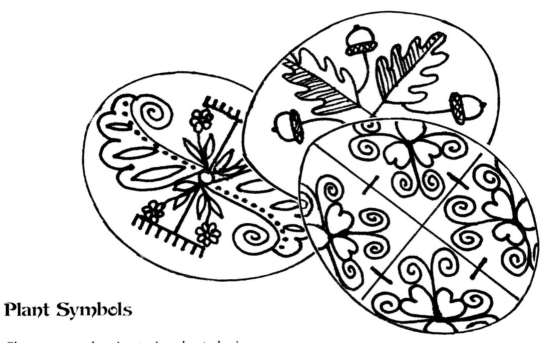

Plant Symbols

Flowers predominate in plant designs.
Since the native artists drew on nature's beauty, they
used the richly colored flowers to enhance their designs.
The following two roses demonstrate a geometric motif.

rose

empty rose

poppy

Barvinok
(periwinkle)

Flowers symbolize love, charity and good will. Sunflowers depict the warmth of the suns rays. Roses are also a very popular flower, symbolizing love and caring.

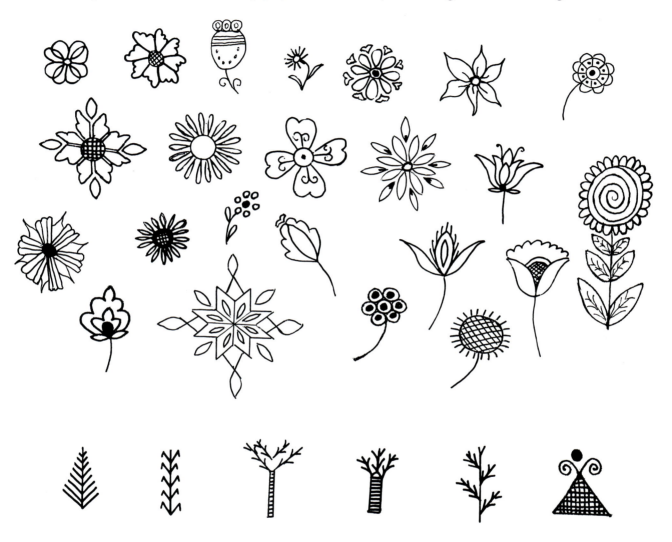

Evergreen trees symbolize eternal youth and health.

Wheat symbolizes good health and wishes for a bountiful harvest.

There is a rich variety of plant motifs.

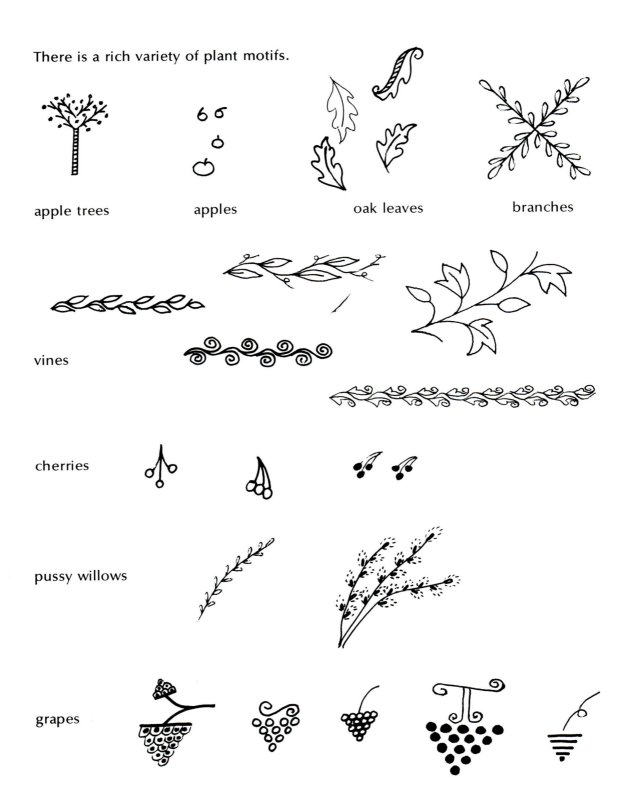

apple trees

apples

oak leaves

branches

vines

cherries

pussy willows

grapes

Animal Symbols

Storks, chicks, hens,
roosters, all symbolize
fulfillment of wishes
and fertility. The bird is not
depicted flying and is shown at rest.
Here again you can see the geometric influence
in the many styles of fowl.

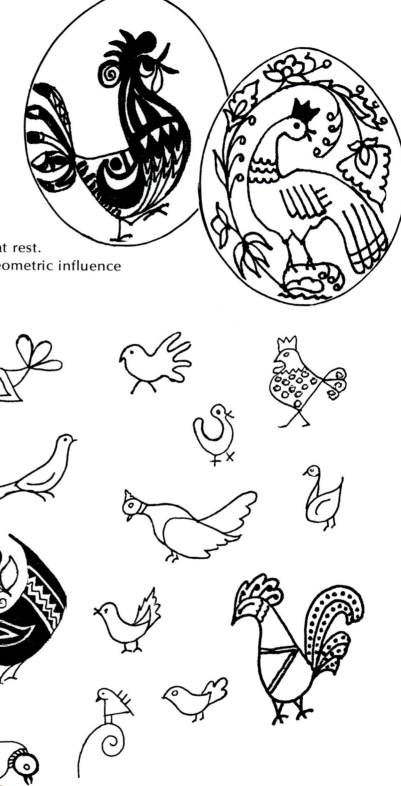

Animal Symbols

Deer and horses symbolize a wish for good health, wealth, and prosperity.

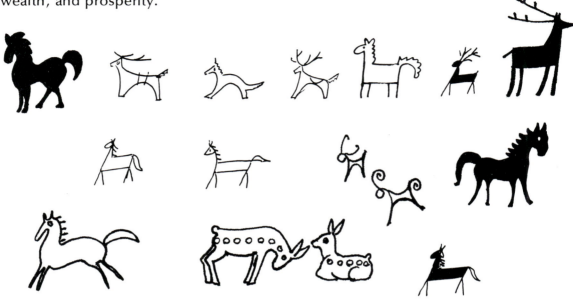

Rams are much like the horse and deer in the symbolism of wealth and prosperity.

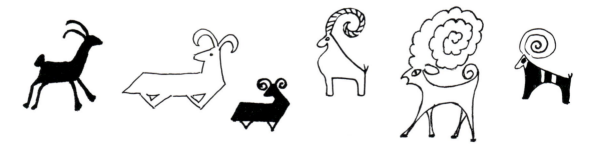

The lion is a symbol for strength but is not very common.

Fish have been known as the early symbol for Christianity.

Butterflies are common designs. All drawings of insects are called butterflies.

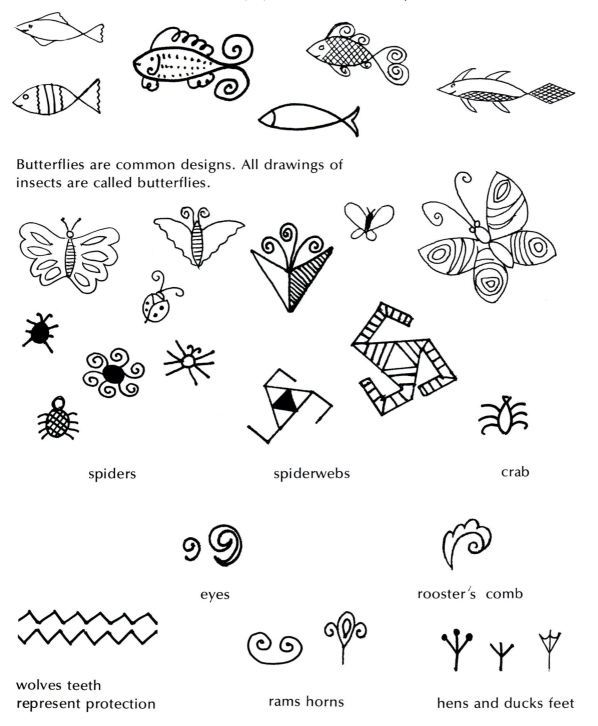

spiders spiderwebs crab

eyes rooster's comb

wolves teeth
represent protection rams horns hens and ducks feet

Geometric Symbols

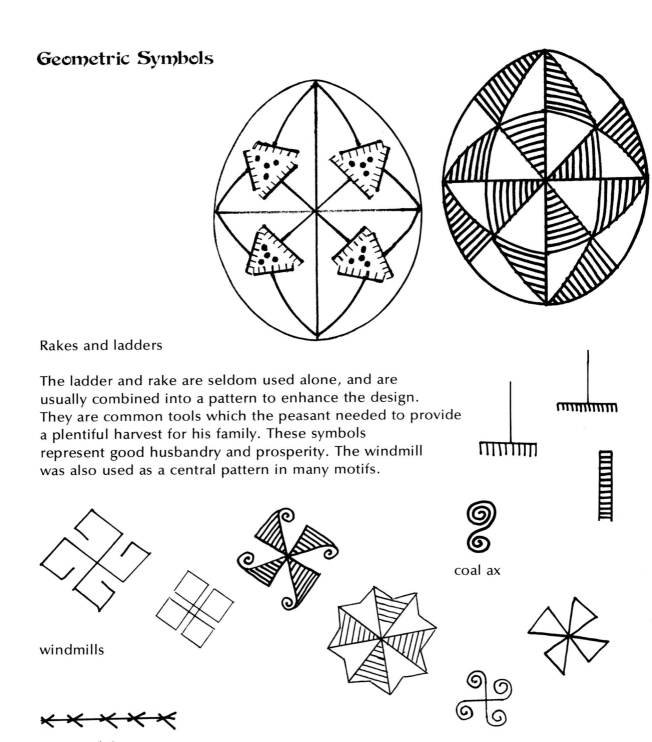

Rakes and ladders

The ladder and rake are seldom used alone, and are
usually combined into a pattern to enhance the design.
They are common tools which the peasant needed to provide
a plentiful harvest for his family. These symbols
represent good husbandry and prosperity. The windmill
was also used as a central pattern in many motifs.

coal ax

windmills

crown of thorns
This signifies the crown of thorns worn by Jesus on the cross.

Drops

Drops usually symbolized the fallen tears of Mary as she wept for Jesus on the cross. Sometimes, in an all over dot pattern, the dots suggest the stars. Dots are a beautiful way to divide space in patterns (instead of a line). They add color and harmony to many designs.

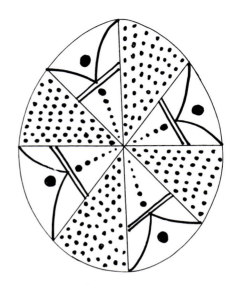

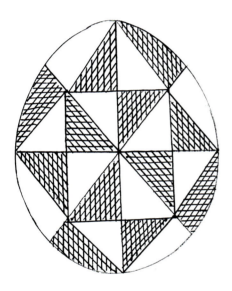

Triangles

Triangles are very popular in typical Ukrainian designs. They symbolize several forms of the trinity. They may represent air fire and water or heaven, earth and hell, or the family (father, mother and child), sun, thunder and bonfire, and especially, the Father, Son, and Holy Spirit.

Net

The crisscross design symbolized the net to which Christ referred when He said we Christians were to be "fishers of men".

Sun and stars

The sun and stars symbolize life itself; growth and good fortune.

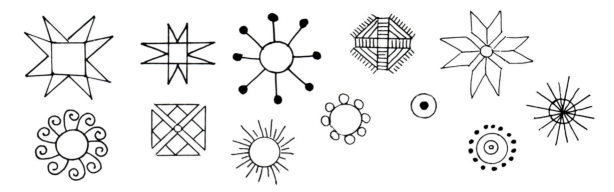

Crosses

Crosses remind us of Christ's victory over death. Easter eggs with one or three bars in all variations have a purely Christian significance but in general, they are not very widespread.

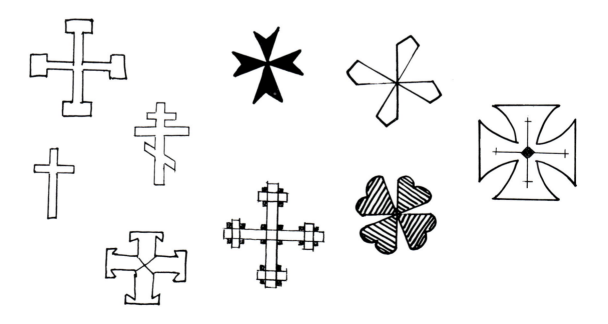

Churches

A typical church egg, a favorite of Hutzals, is a
geometric combination of a cross and triangles.
The net or grating which covers the entire surface with
triangles, spirals, and rhombi has only a decorative use.

Ribbons

The ribbons symbolize a never ending line representing
everlasting life. The ribbons of waves represent water.
An important geometric element is the endless line
(Bezkonechnyk) that goes entirely around the egg and meets.
It is a wavy line which arises from the joining of several
concentric circles and is continued in the direction of the
following circle. The name comes from the continuous
nature of the form which proceeds forward in many curves
without any visible endings.

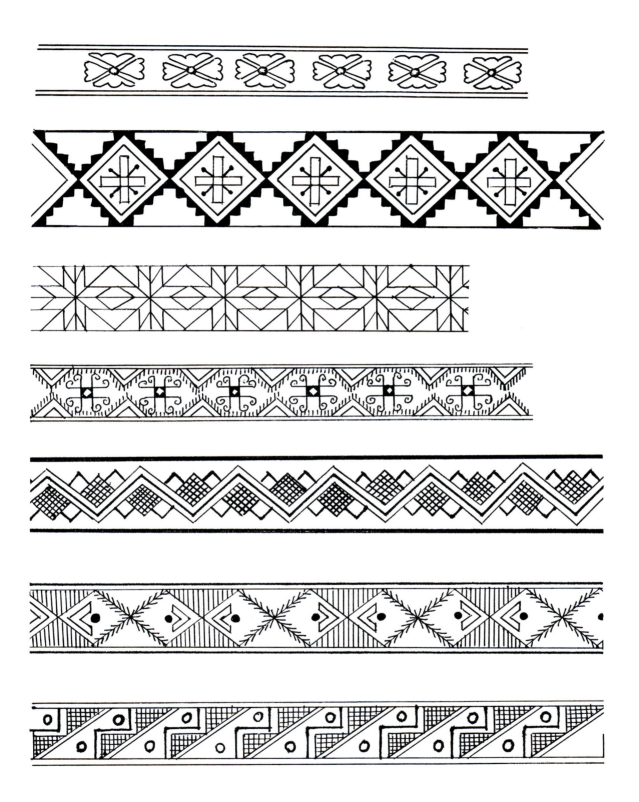

Some designs for the end of the egg.

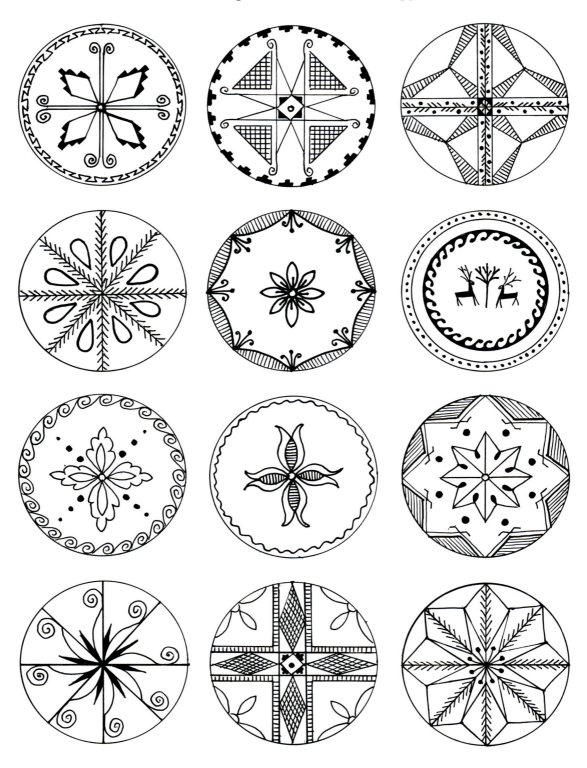

How to Make a Ukrainian Easter Egg

Step 1
Preparation
of Materials

1. Eggs

This batik method of decorating may be used on several kinds of eggs. Duck, goose, and chicken eggs are good as long as they are fresh and the shell is smooth and unblemished. Ukrainian people generally use chicken eggs. We prefer to purchase them from the farm but commercially washed eggs may also be used. If washing is necessary rinse carefully, without rubbing, in a quart of warm water which includes one tablespoon of white vinegar. Avoid using soap or detergent. Blot the eggs with a clean cloth. We use raw eggs because they are traditionally used for decorative purposes and not meant to be eaten. Boiling the eggs causes a small amount of water to seep under the shell. This can damage the design in a few weeks time.

The whole raw eggs will keep indefinitely if the shell is in good condition, so, before we begin, we hold the egg up to a light and check for weak spots or hairline cracks. Be very selective when choosing your eggs. They should be at room temperature before decorating to avoid sweating, because wax will not adhere to a wet surface.

2. Kistka (stylus)

The kistka is a pen which writes with melted wax. This tool consists of a metal funnel attached to a stick which is wrapped with copper wire. The wire is used to keep the tool hot and to hold the metal tip steady. Kistkas come in sizes which write lines of fine, medium, and heavy widths. Experiment on a practice egg to get used to the kistka. Heat the head of the kistka directly in the flame. When hot, scoop a

small portion of beeswax (about the size of a BB shot) into the larger part of the funnel and begin to write on the egg. We use long strokes rather than short sketchy lines. When we use a new kistka and wax, the first lines are almost transparent. Gradually, the wax will turn black from the carbon in the flame. By holding the kistka perpendicular to the egg the wax flows more evenly and makes a smoother line.

The kistka may drip wax if overheated or overloaded. You will learn to control this with practice. If the kistka should start to burn, quickly blow it out. Eventually the wax will protect the wood from burning. Impurities in the wax and soot from the candle cause the kistka to become clogged occasionally. To clean the kistka, scoop the tip full of *candle*

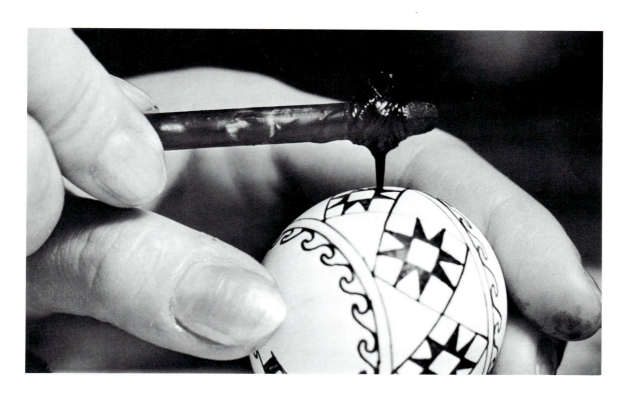

wax, heat in the flame, and tap against a newspaper until it is empty. The funnel is clean if you can see through it.

3. Candle

The candle is used to heat the funnel part of the kistka. It is better not to use a brand new tall candle because you'll have to reach up too high! This is a good chance to use up the short candles you may have stored away.

4. Beeswax

The beeswax is used because it has a high melting point making it possible to get even lines which will not smear. If you use candle wax and place the egg in the dye bath, the dye would seep through and spoil the design. Beeswax prevents this from happening.

5. Dyes

Mix dyes according to the directions given on the container. Use clean wide mouth pint jars. (salad dressing and peanut butter jars are excellent). You will want to cover the dyes when you are not using them. It is very important to allow the dyes to cool to room temperature. Except for orange and pink, add a tablespoon of vinegar to strengthen the colors. Dyes may be stored and used for more than one season. Vinegar may be added several times during the life of the dye. After dipping several dozen eggs (seven to ten) the dye mixture may need to be replaced.

6. Spoons

You will need a tablespoon or a teaspoon to dip the eggs into each color.

7. Working area

Cover a table with newspapers and place some paper towels where you will rest the egg as you work. Paper towels will also be needed to blot the egg dry when you remove it from the dye. It is possible to re-use the towels provided you use

them to blot the same color each time. This way you can conserve towels. Try to get a desk lamp so you will have a bright light. It is important to see well. You may want to set your jars on a tray for easy mobility and storage.

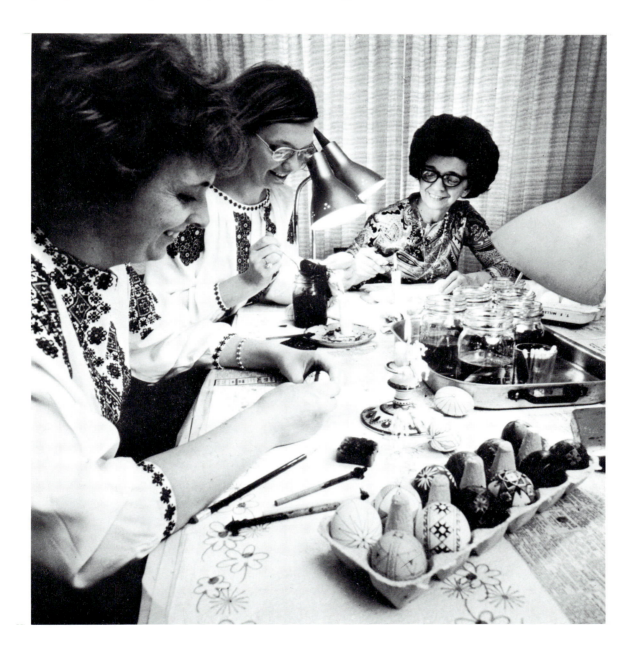

8. Soft cloth or tissue

This will be used for wiping the melted wax from the egg when you are in the final step.

9. Gloss Coating

Clear gloss varnish, shellac, or art spray may be used. Varnish and shellac are available in hardware and paint stores. Art spray is available in hobby or art supply stores.

10. Pencil

A hard #3 pencil is best for drawing the basic dividing lines on the white eggs before you begin to apply the wax. Using a pencil however, is optional.

11. Paint Brush

Occasionally, a small area on your design can be filled in with a fine paint brush or a cotton swab.

12. Egg Rack

This rack is used when you wish to melt the wax from the egg and also when the gloss is drying. It is a board with nails pounded into it to form triangles to hold the eggs. You may use a piece of heavy cardboard instead of a board.

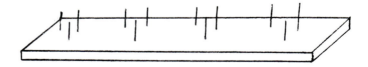

Step 2
Application
of Designs

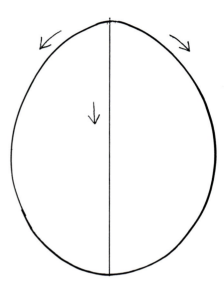

Figure 1

Place your arms on the table holding the egg on a paper towel. Starting at the top of the egg, hold the lead pencil steady in one hand and rotate the egg in the other making a light line lengthwise.

Again at the top, draw another light line crossing the first at right angles. The egg will now be divided into quarters. (Figure 1)

Figure 1 as seen from the top.

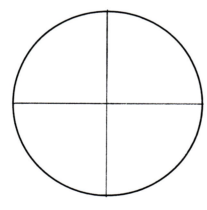

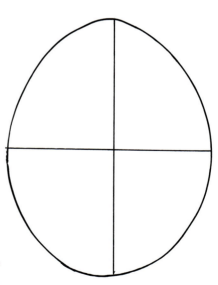

Figure 2

Now, draw a horizontal line around the middle of the egg, dividing the egg into eight equal parts. Remember, never erase pencil marks on the shell, for erasures will cause smudging. (Figure 2)

51

The next step is to draw diagonal lines beginning at the center and, with a long stroke, divide each section again forming a basic pattern with eight divisions on each side of the egg. (Figure 3)

These lines are drawn to give you a framework from which to form your full design.

You are now ready to apply the wax to the design. With the heated kistka, cover the pencil lines with long strokes. Try to relax your hand and not press the tool into the shell.

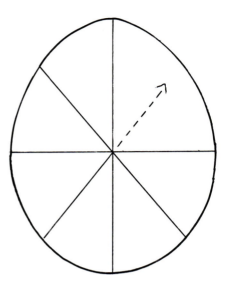

Figure 3

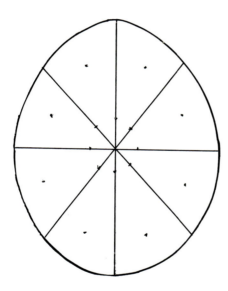

Figure 4

The star pattern is a favorite. Put dots on each of the sections equal distance from the center as indicated. (Figure 4)

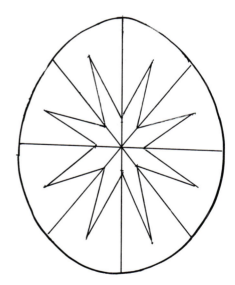

Figure 5

Connect the dots with wax lines forming a star as seen in (Figure 5). All these wax lines will remain white in the completed design.

Place the egg on a spoon and ease it into the yellow dye. In approximately five to ten minutes the egg may be removed from the dye and patted dry. Do not rub.

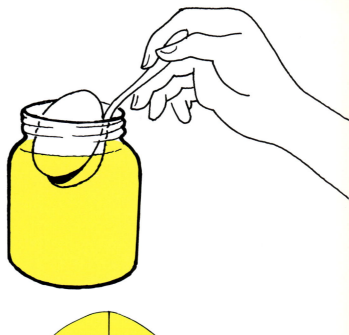

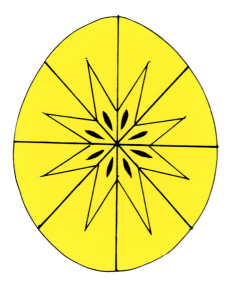

Figure 6

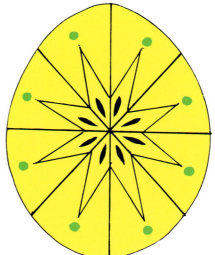

Figure 7

Wherever wax is applied to the yellow egg, the areas will remain yellow in the final design. Following the next figure, make petals in each section of the star. Fill them in solidly with wax. Do this on both sides of the egg. (Figure 6)

For applying green to the design, we use a small paint brush, cotton swab or a toothpick. Apply a small amount of blue or green dye to the design at the outside tip of the points. Blot them dry with a clean tissue. (Figure 7)

The color from the blue dye on the yellow egg will produce a beautiful green. Don't be concerned if the blue dye smears a bit.

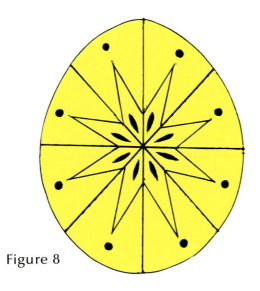

Figure 8

Now cover each dot with wax. The orange dye will cover over any green color not covered with wax. (Figure 8).

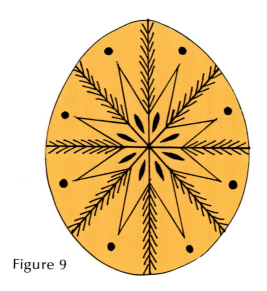

Figure 9

Next dip the egg into the orange dye. In five to ten minutes, remove it and pat dry with a clean tissue. With a kistka, draw a fringe on each line leading away from the star as seen in (Figure 9).

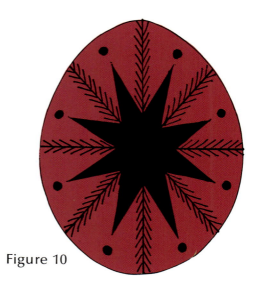

Figure 10

The egg is now ready for the red dye! Proceed to dye the egg in the red dye, then pat dry. Fill in the entire star with a coat of wax. If it is easier, you may cover one section at a time. Don't worry about covering over the inner lines of the star or the petals with wax. This is the way to do it correctly. Try to cover it solidly, leaving no spaces uncovered. It's a little like coloring in a coloring book. Fill it in completely as seen in (Figure 10).

Now we suggest that you dip the egg into the black dye. After ten minutes or longer, the egg may be removed and patted dry. Your egg is now finished as far as applying the design is concerned. The exciting moment has now come. You must melt the wax in order to see the colors beneath.

When we demonstrate how to make decorated Ukrainian eggs we often melt the egg in the flame of the candle. This is done by carefully holding the egg into the side of the flame until it "looks wet" (about two or three seconds).

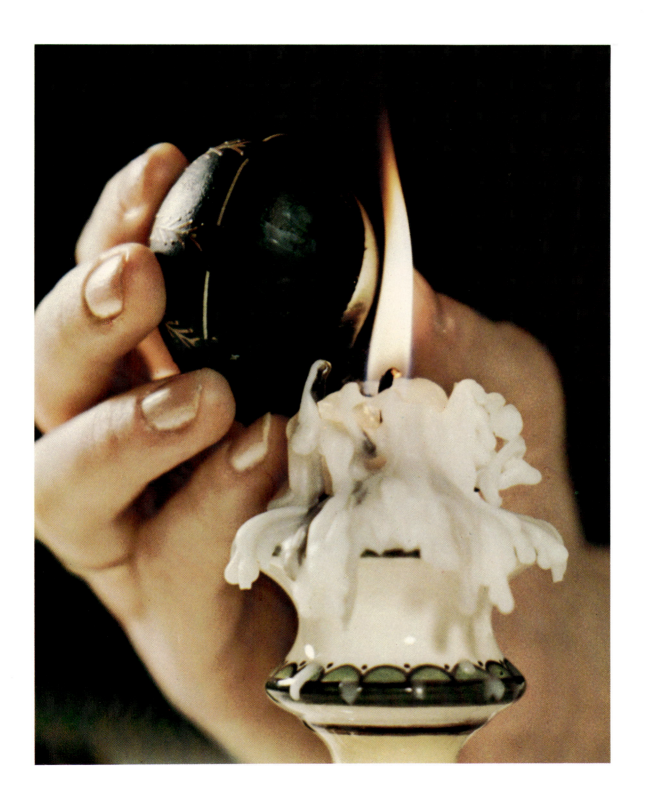

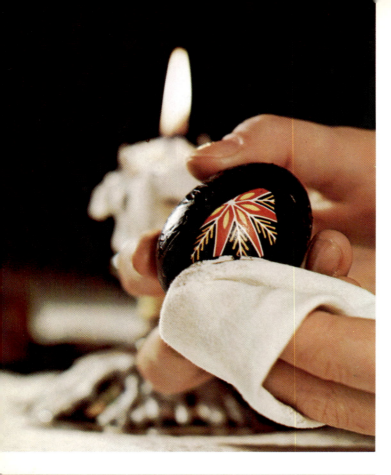

Then, with a clean soft cloth, wipe off the wax. This is indeed an exciting step for all the work you have done comes to colorful life in your hand. Be careful not to hold the egg *over* the flame because carbon will collect on the shell and darken the design. Also do not attempt to heat too large a portion of the egg at one time.

Your finished egg will be a pleasant surprise! (Figure 11)

Step 3 Completion of the Egg

Since we make dozens of eggs, we use a faster method for melting the wax. A board with 1½ inch nails grouped in sets of three is used. The egg is placed into a preheated oven set at 180° farenheit. The eggs are then allowed to heat gently for fifteen to twenty minutes. The oven door should be kept open. We are careful to *check from time to time so that the eggs do not become too hot.* When they are warm and look glossy we take them out one at a time from the oven and wipe off the melted wax with a clean cloth. This is where old pajamas and T shirts really come in handy. After all of the eggs are wiped dry and cooled, they may be varnished in the following manner.

First, spread some newspapers on the

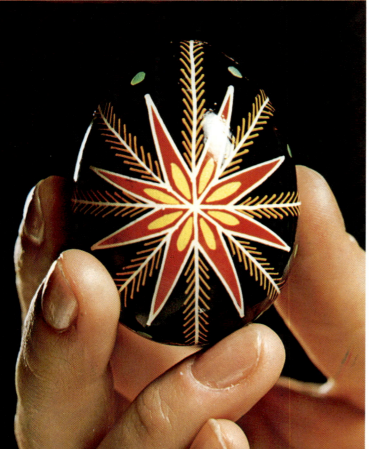

Figure 11

oven door, open a small can of clear gloss varnish, turn the heat to the "off" position. Then take one egg at a time and gently, with your fingers, apply a thin coat of varnish. Make sure you cover the whole egg and then place it back on the rack in the oven to dry. Keep the oven door ajar slightly while drying the eggs. It will probably take several hours for the eggs to dry. When the eggs are dry, they are ready to enjoy! The decorated egg, though fragile, will keep for years, long after its contents dry out.

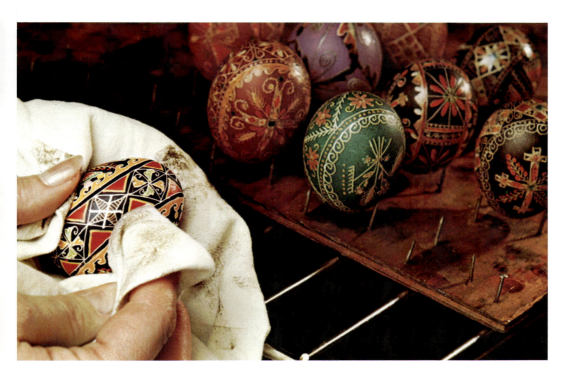

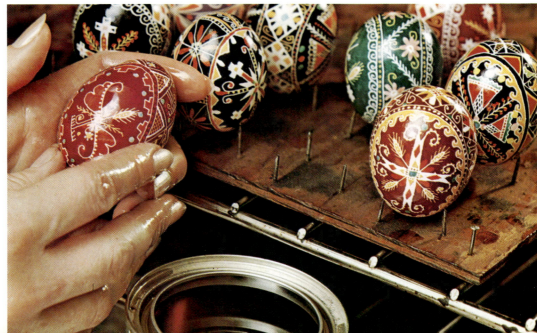

Suggested Designs

On the following pages you will find the step-by-step diagrams of each of these eggs in corresponding order. Mrs. Luciow has suggested a good variety of designs for the serious beginner.

In the diagrams, beginning on page 62, the first drawing shows the design that should be applied to the white egg. The second drawing shows the lines that should be added to the design after the egg has been dipped into the yellow dye. The third drawing shows the lines that should be added after the egg has been dipped into the third color, and so on, depending upon the number of colors. The darkest color is always the last.

The egg is then ready to be melted and varnished. Each individual egg has a suggested final color. However, you may choose any final color that you prefer.

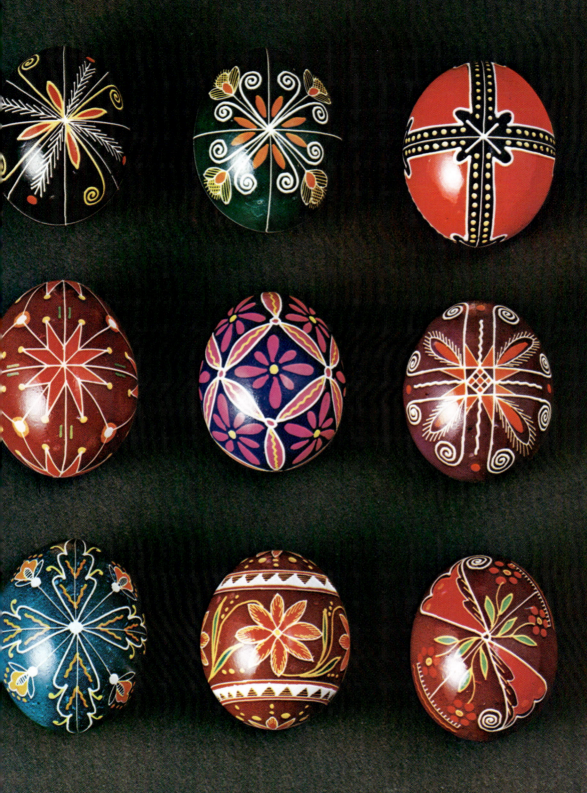

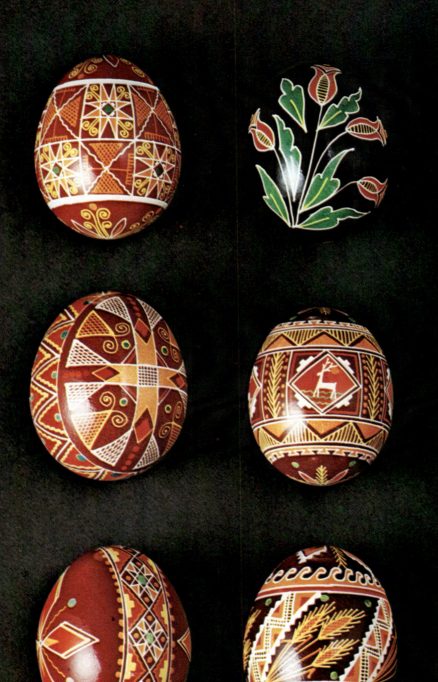
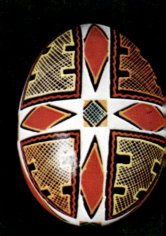
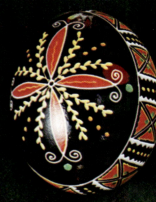
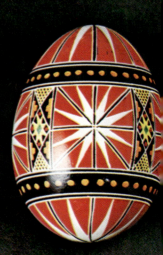

Diagram of the eggs shown on page 59.

Diagram of the eggs shown on the facing page (60)

Step by step diagrams:

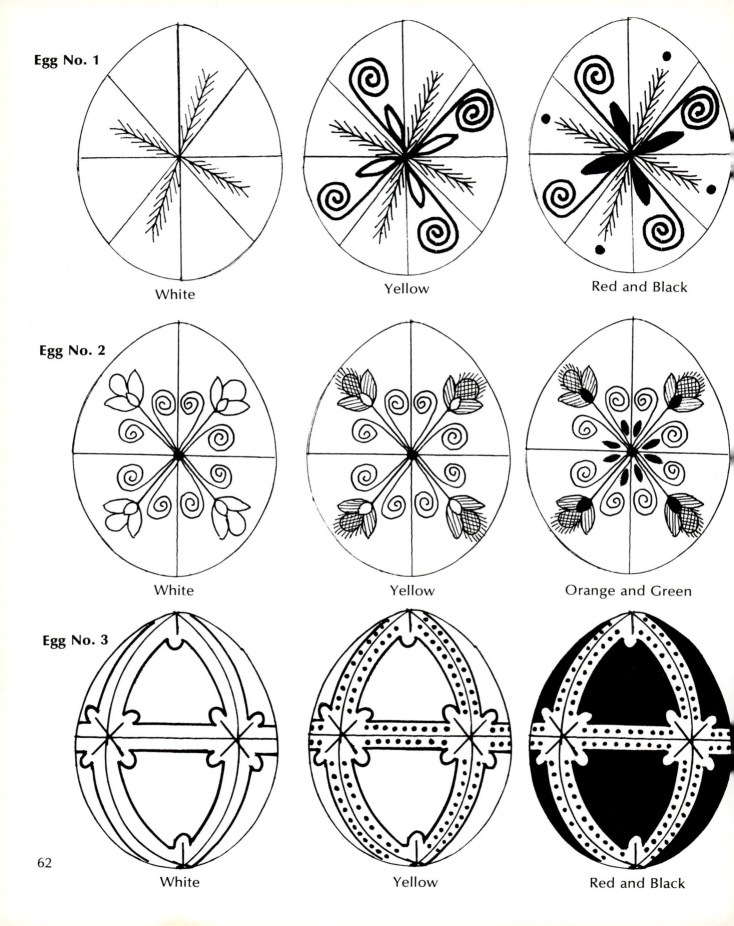

Egg No. 1

White Yellow Red and Black

Egg No. 2

White Yellow Orange and Green

Egg No. 3

White Yellow Red and Black

Egg No. 4

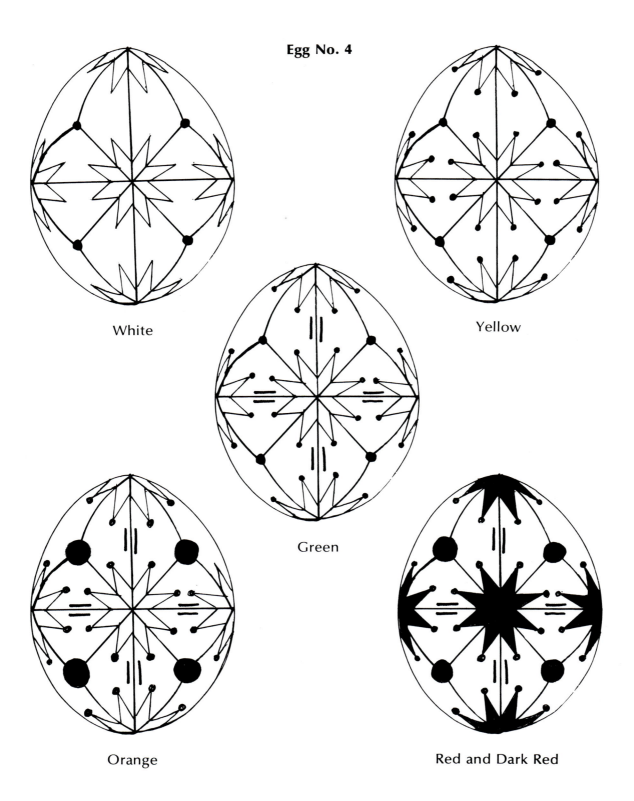

White

Yellow

Green

Orange

Red and Dark Red

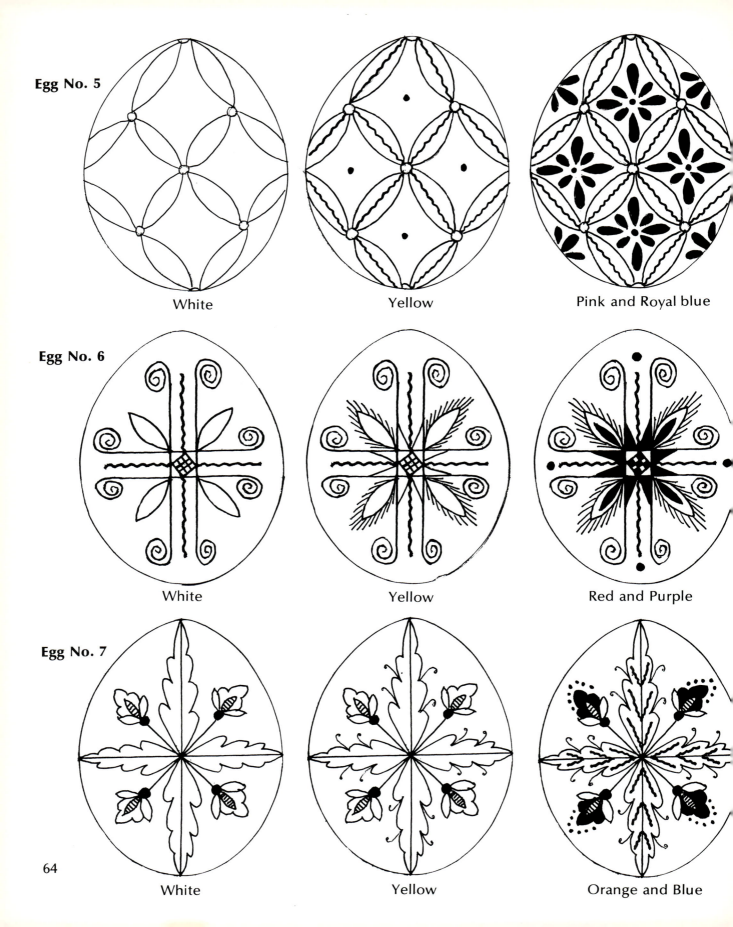

Egg No. 5

White Yellow Pink and Royal blue

Egg No. 6

White Yellow Red and Purple

Egg No. 7

White Yellow Orange and Blue

Egg No. 8

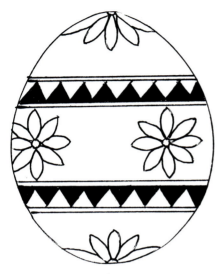

White

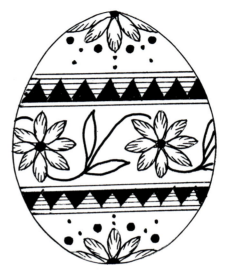

Yellow

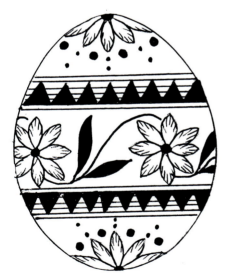

Green

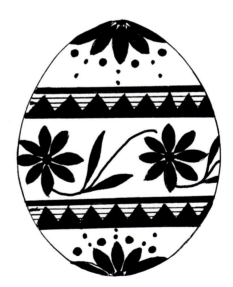

Red and Dark Red

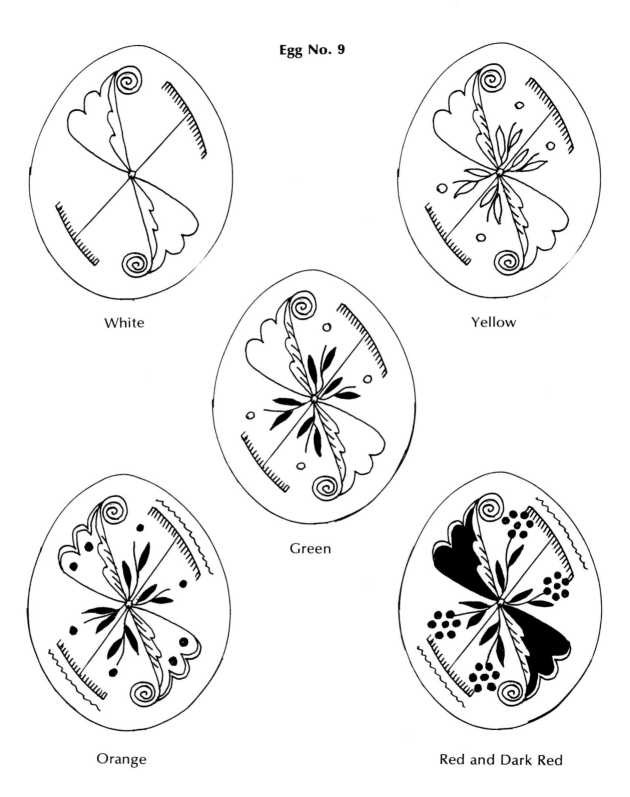

White

Yellow

Green

Orange

Red and Dark Red

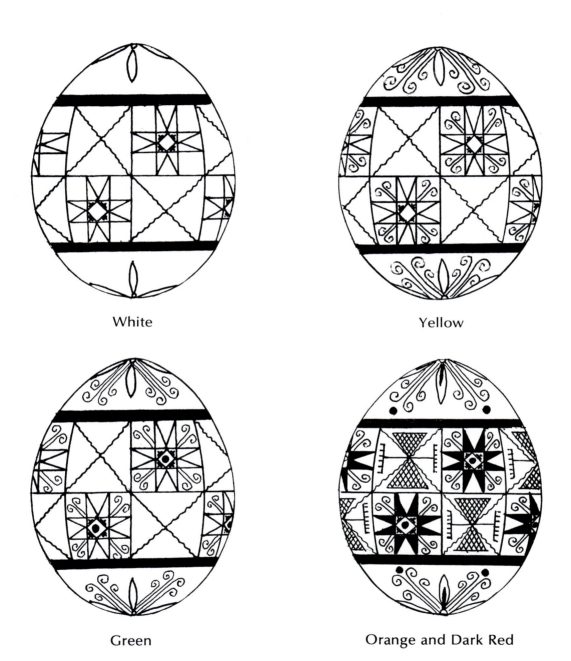

White

Yellow

Green

Orange and Dark Red

Egg No. 11

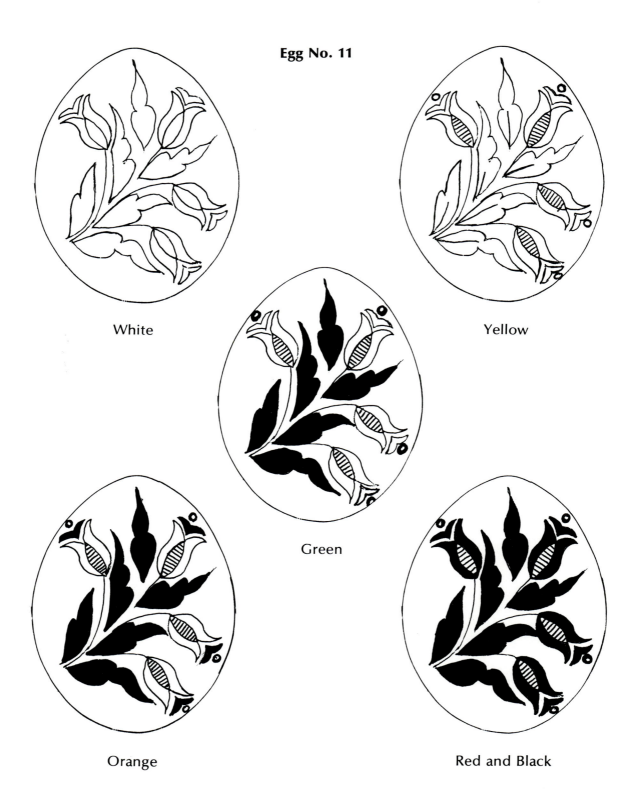

White

Yellow

Green

Orange

Red and Black

Egg No. 12

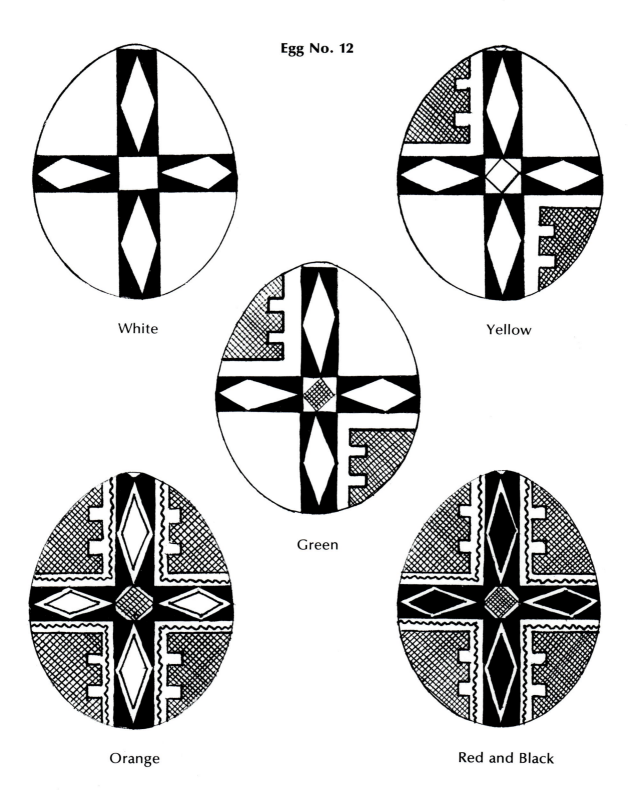

White

Yellow

Green

Orange

Red and Black

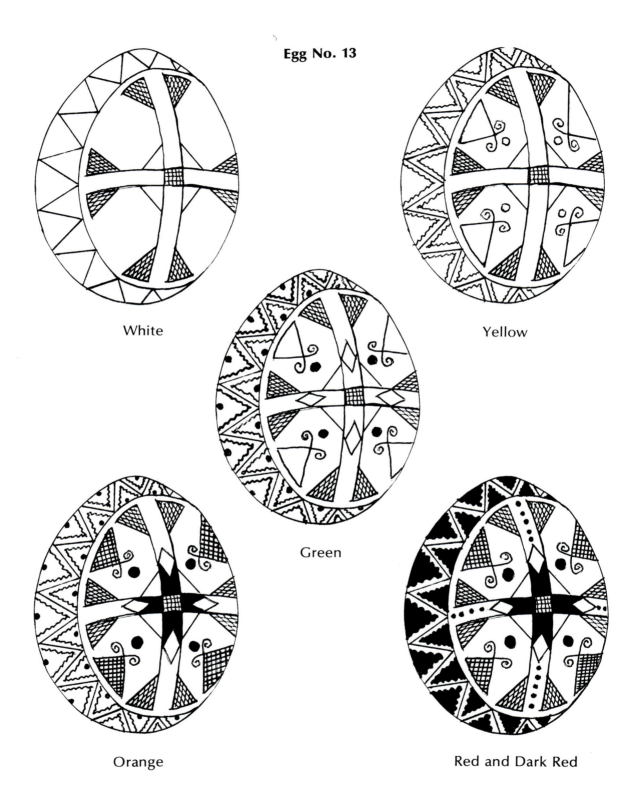

White

Yellow

Green

Orange

Red and Dark Red

Egg No. 14

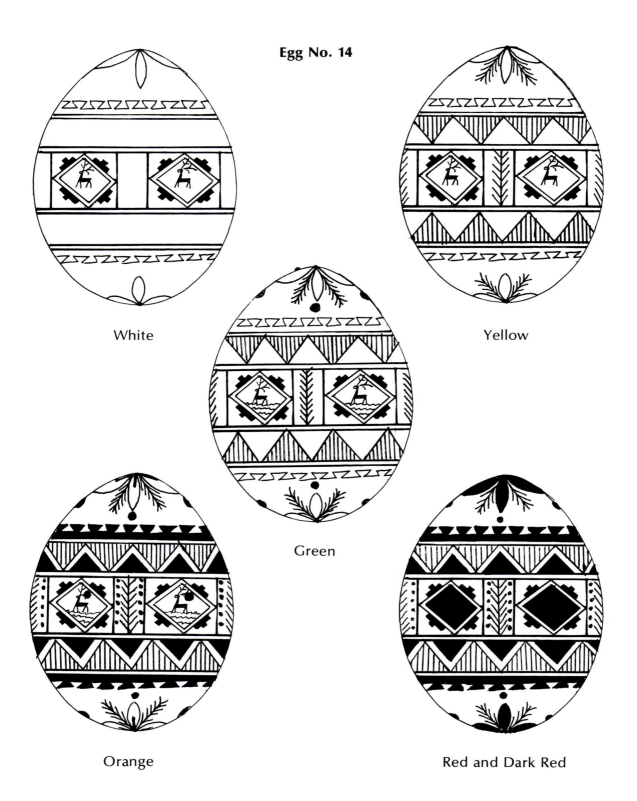

White

Yellow

Green

Orange

Red and Dark Red

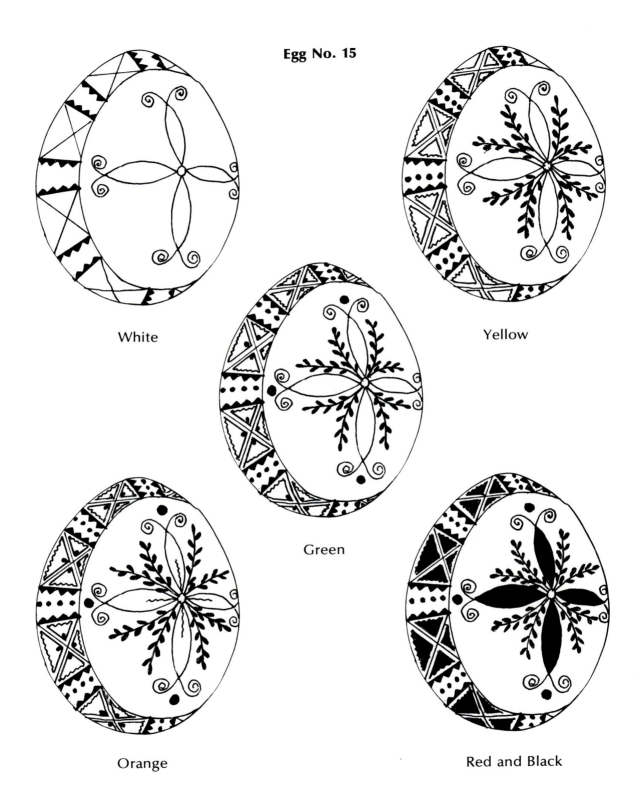

White

Yellow

Green

Orange

Red and Black

Egg No. 16

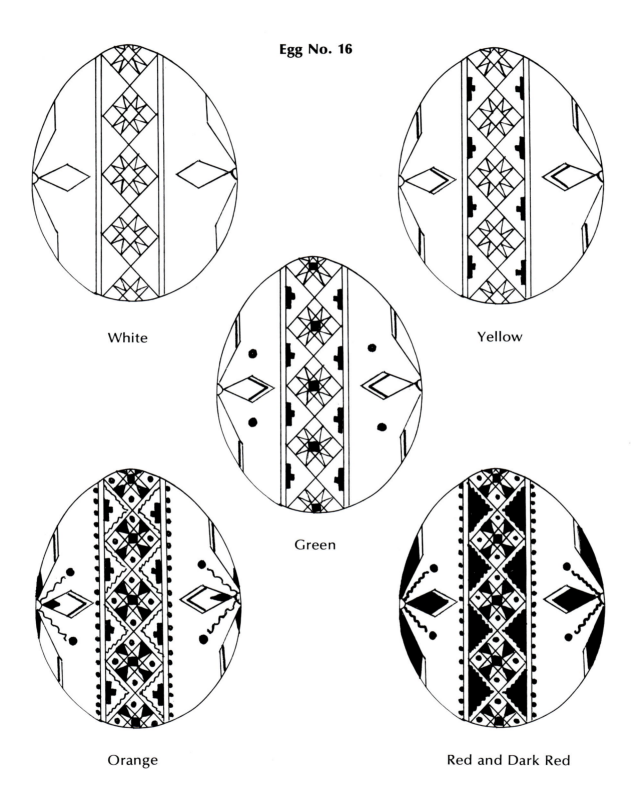

White

Yellow

Green

Orange

Red and Dark Red

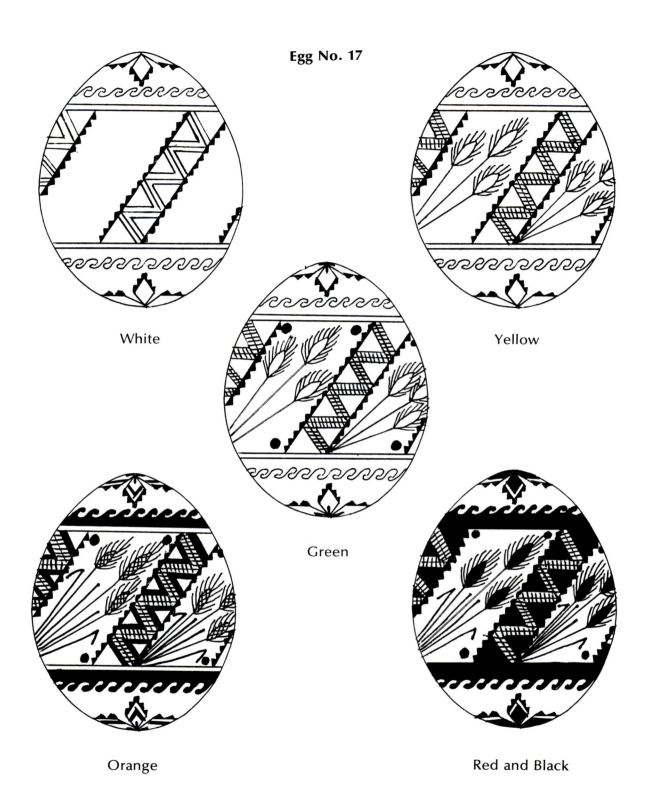

Egg No. 17

White

Yellow

Green

Orange

Red and Black

Egg No. 18

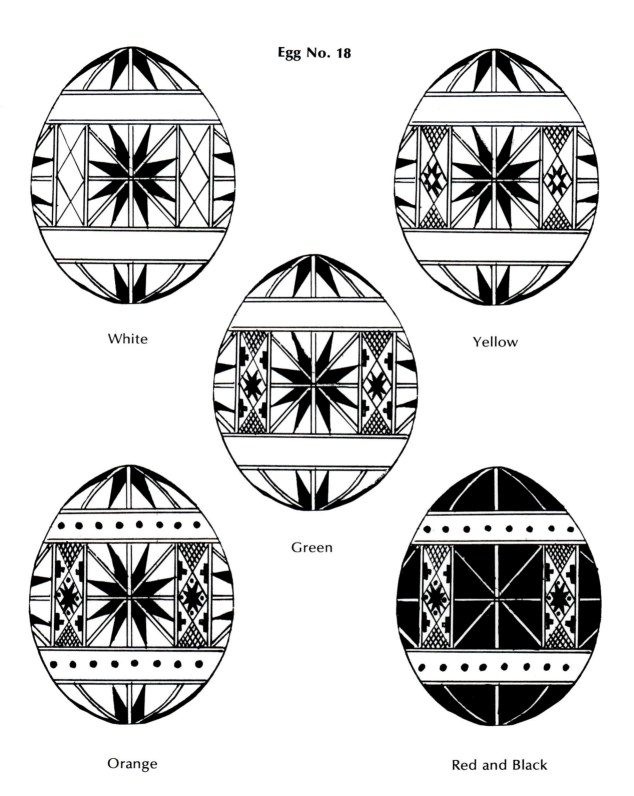

White

Yellow

Green

Orange

Red and Black

Favorite Established Designs

Over the centuries, many designs developed and became somewhat standardized. We have chosen some of the familiar and charming favorites which show the variety as well as the artistic method of characterizing surrounding nature and life.

The first egg in the top row is called "Neighbors". The second one is called "Windmills". The third egg is "Forty Eight Days of Lent".

The first egg in the second row is called "Churches". The second egg in the second row is called "Pine trees". The third egg is named "Paska".

The first egg in the third row is called "Horses". The second egg is "Gypsy Road". The third is known as "Sunflower".

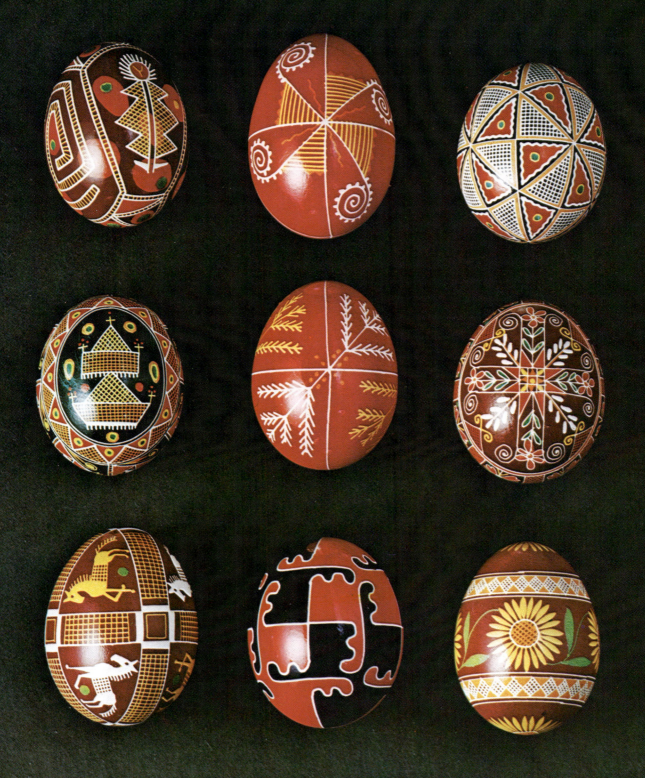

"Trypillian" Designs

A population of Neolithic peoples who lived in the Ukrainian area from 5,000 to 2,500 B.C., were known as the *Trypillian* culture. Archeological diggings in 1893 uncovered the ancient remains.

Their pottery is very powerful and beautiful. The designs are of three colors; usually white and black against the red clay background. The form of design is spirals and whorls which encircle the pot in a pattern of spiral meander. These rich designs signified eternity and the cycle of life.

This same meander can be seen on contemporary Ukrainian embroidery as well as on Easter eggs. The designs on page 80 are superb examples of this art, created by Luba Perchyshyn, our aunt.

Other Unusual Methods of Decorating Eggs

The pysanka and krashanka are the most well known types of Ukrainian Easter eggs. There were others however, which were decorated in various ways. The first egg in the top row on page 81 uses the wax resist process. Instead of a kistka to apply melted wax to the shell, a pin was dipped in hot wax and drawn quickly on the white egg in a tear drop shaped form. These eggs were often done in two colors and were very popular in Lemkivschyna which was located in the northwestern area of Galicia along the northern fringes of Carpatho Ukraine.

The second egg in the top row was polished and formed in wood. Then a woodburning tool was used to create graceful patterns. A rare but very beautifully decorated egg is the

third egg in the top row. It is created by first drawing a very intricate pattern on a white egg with black or yellow wax. Instead of dipping the egg into various dyes, as we do in our psyanka design, the artist paints with India ink and fills in parts of the design with bright colors. The whole egg is shellacked directly over the waxed areas. The egg is sometimes blown after this process is completed. The result is a delicate pattern which is embossed and can be felt with the finger tips.

The Hutzul people from the Carpathian mountain area near Poland were talented craftsmen with wood. The first egg in the second row shows a wooden egg which is typical of their handwork. Eggs such as this one were polished and then engraved with geometric designs. The incissions were then filled with various colors and the result was much like a psyanka. Wooden eggs were often used as gifts to children, since they were unbreakable.

Another method used in decorating eggs was the beaded egg. The second egg in the second row shows this type of work. A fresh egg was dipped in a thin coat of beeswax and allowed to cool. Then tiny colored beads were pressed into the wax with the fingers to create lasting designs. This type of work was done mainly in Bukowina where beads were also used on their costumes and embroidery.

The third egg in the second row is of wood which was first polished and then carefully painted using bright colors. These eggs were varnished later and lasted indefinitely. They are being exported from Ukraine at the present time since they are not perishable. Some of the eggs were polished and then inlaid with beads, mother of pearl, wire, and other shades of wood to create shimmery works of art, as seen in the first egg in row three. These eggs are being made today by skilled Ukrainian craftsmen from Germany and Canada. The second egg in the third row was made by first dying the egg in one bright color and then a design was scratched in with a sharp fine point such as a pen or a small knife. The design gives the same appearance as light lace.

The last egg in the third row is a wooden egg from eastern Ukraine. This wooden egg is formed and polished and then painted in bright floral patterns with enamel paints.

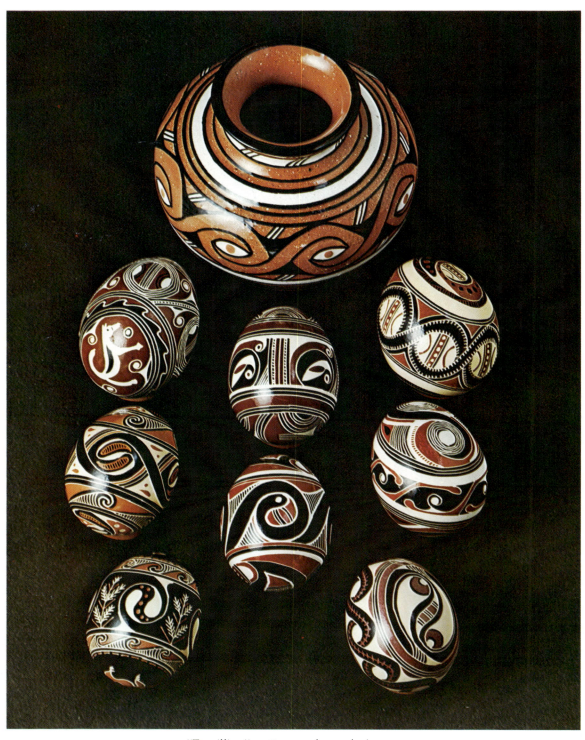

"Trypillian" pottery and egg designs.

80

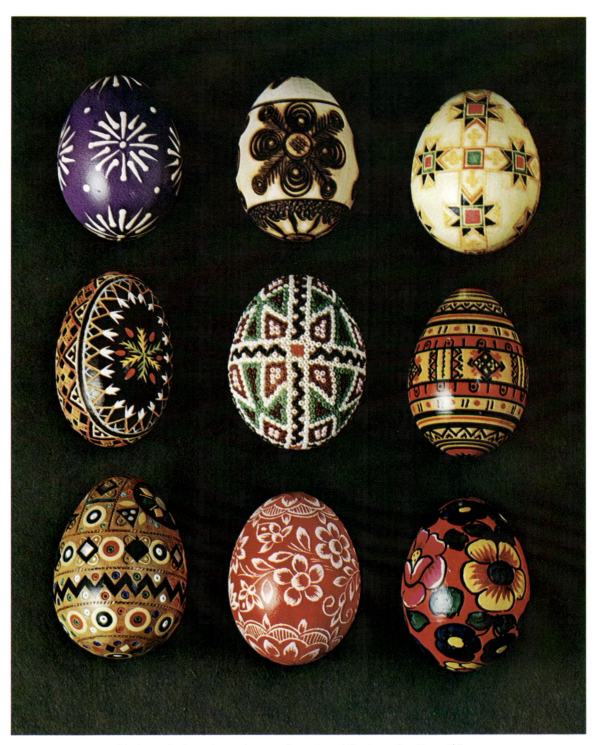

Various designs from the southwestern Ukraine, the Carpathian
mountain area, Bukowina, and the eastern Ukraine.

The Twelve
Basic Patterns

Following are twelve basic patterns for dividing the egg in the very beginning of the design. There are an infinite variety of patterns which can spring from these, as you will soon see.

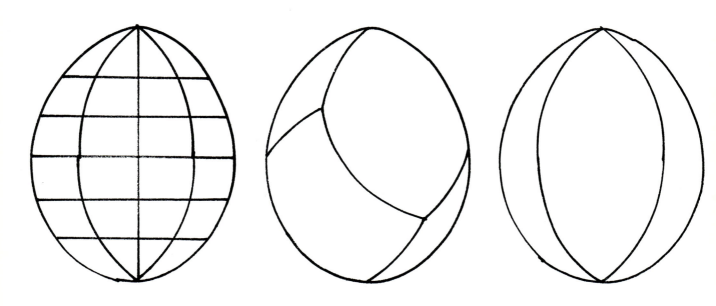

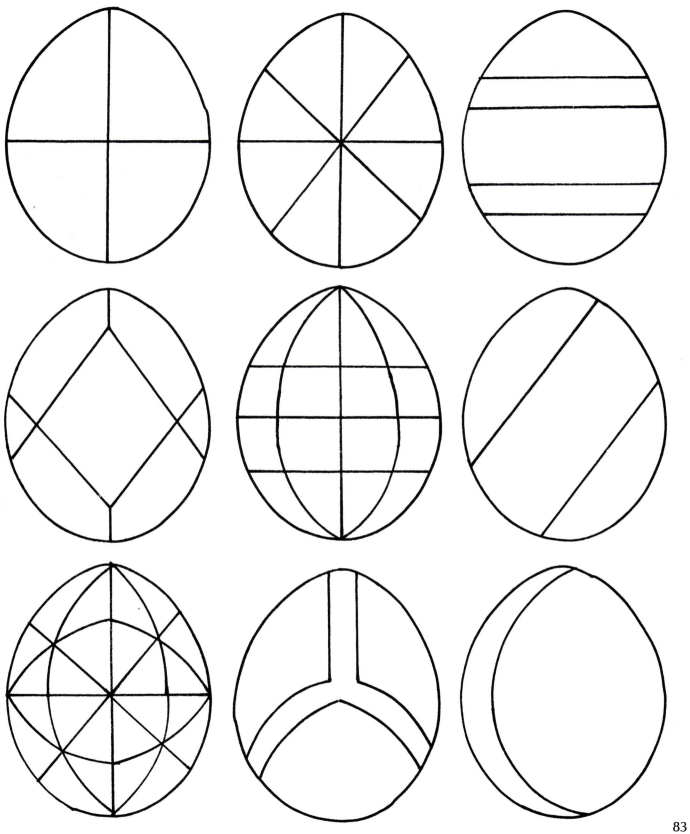

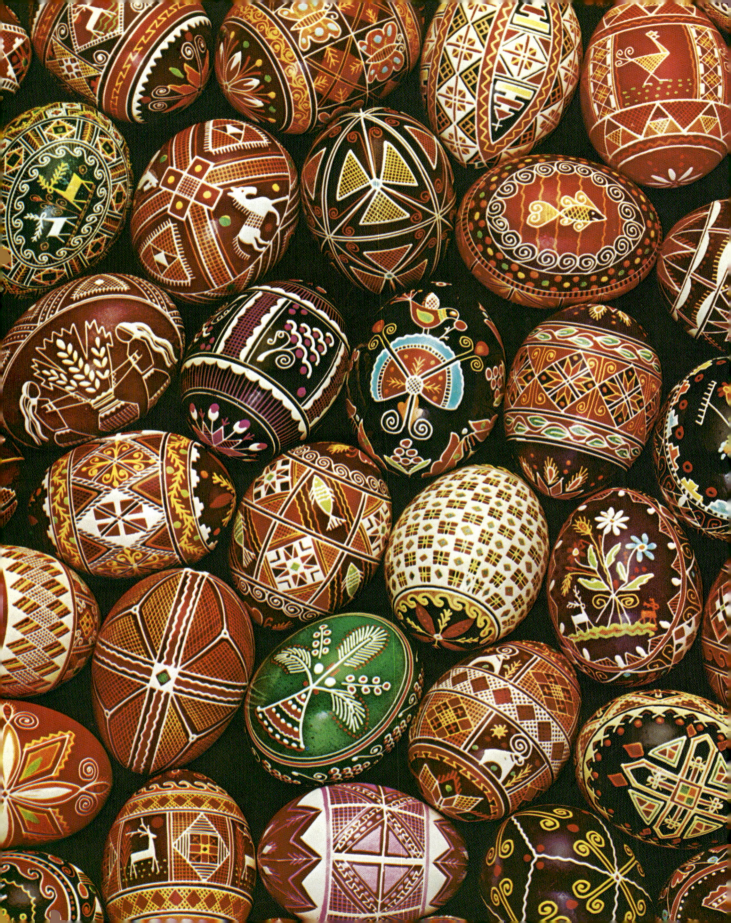

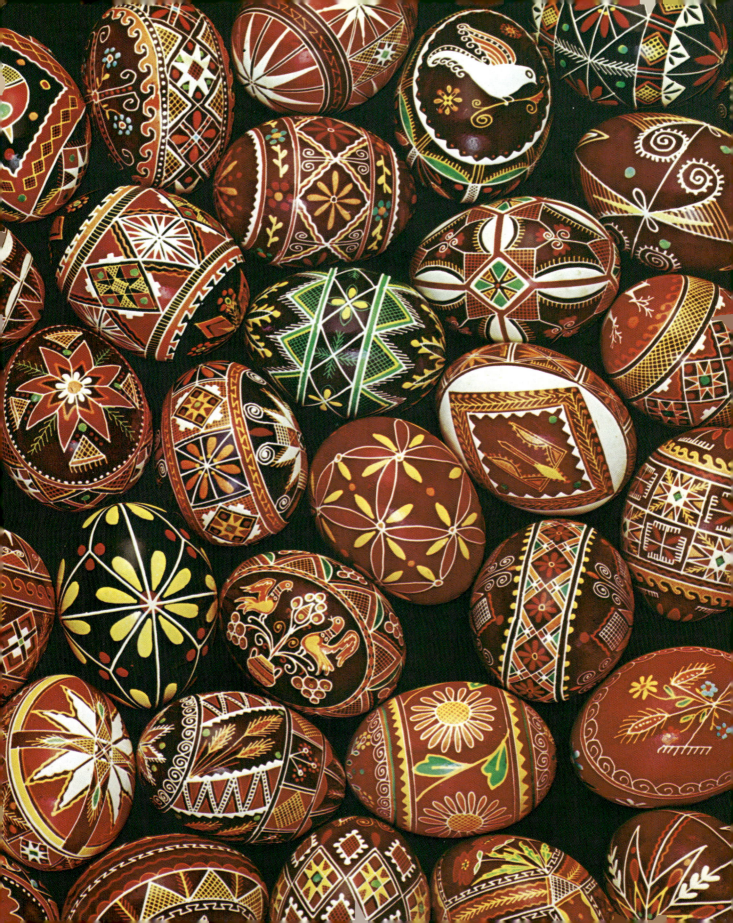

How to Display and Store Your Eggs

Decorated eggs can be beautifully displayed in many forms of wire egg stands, baskets, egg plates, brandy snifters, egg cups, shot glasses, and even rubber washers.

We recommend that you choose an egg stand which will compliment the design on the egg rather than detract from it. The more simple the stand, the easier to enjoy the design on the egg.

The eggs should not be displayed over a fireplace where they may become heated, or in the direct sunlight. They also should not be closed in an airtight area such as a glassfront china cabinet. The inside of the egg is evaporating gradually and needs to have air circulating around it. If you have small children, display the eggs where they can't reach them since they are delicate and should not be handled unnecessarily.

If you would like to store the eggs in a safe place for a period of time, put them in a regular cardboard egg carton and place them in a cool dry cupboard. Just avoid tight places where air cannot reach the eggs, such as plastic margarine containers or closed plastic bags. Also try not to use a plastic egg carton; they don't let the air circulate as well.

All these directions are just for your information. Do not be concerned, the eggs generally keep very well. We have some which are forty years old.

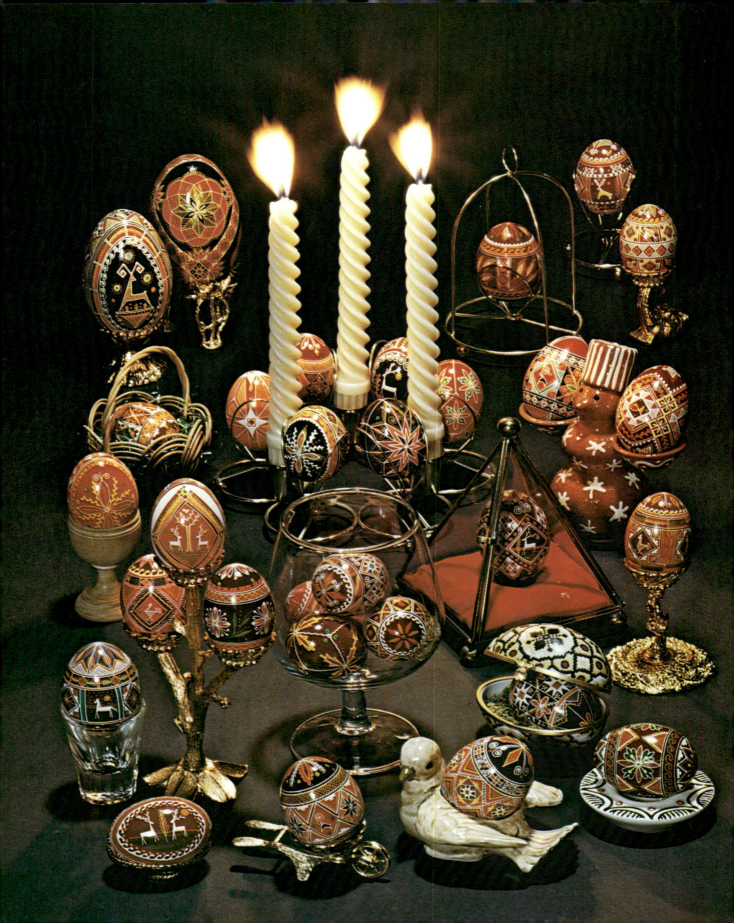

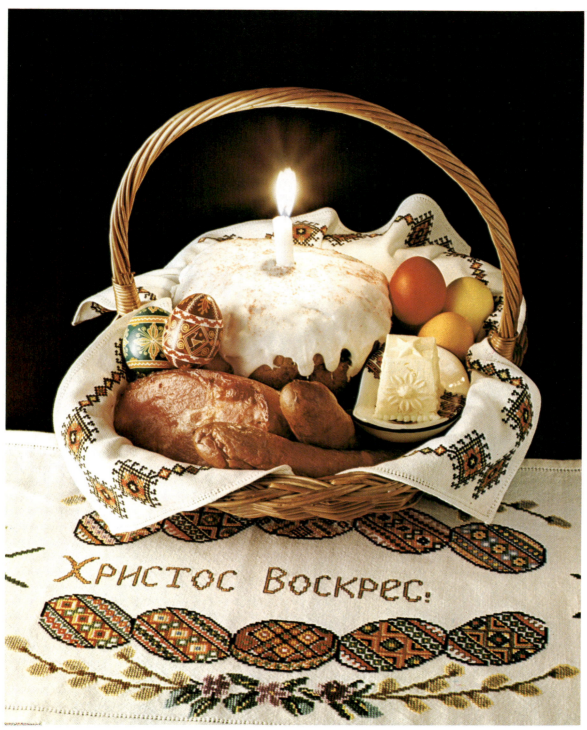

The paska (Easter bread), ham, sausage, cheese, butter, krasanky, and pasanky
ready to be taken to church on Easter morning for a blessing.

Information on Purchasing Materials, Bibliography, and Index

Information on Purchasing Materials,

Materials needed are: Kistka's
 dyes
 beeswax
 varnish

We have tried several types of dyes and find the anilyne dyes to be the most beautiful and long lasting. They come in thirteen colors (yellow, orange, red, blue, green, black, pink, dark red, brown, royal blue, turquoise, wine, and purple).

Kistkas come in three sizes (fine, medium and heavy). A cake of pure beeswax, weighing approximately one ounce, will last for several dozen eggs!

These materials may be bought in a kit, or separately, depending on your need. They are quite inexpensive, compared to the materials needed for other hobbies, and last for five to eight dozen eggs.

For information on prices of materials we suggest that you contact:

Ukrainian Gift Shop[*]
2422 Central Avenue Northeast
Minneapolis, Minnesota, 55418

 [*] Or contact your local Ukrainian store.

The clear gloss urethane varnish can be bought at most any hardware store. Buy the smallest can available as you need only a few drops per egg.

The Electric Kistka

Thanks to modern ingenuity! Several different people from Canada and the United States have developed electric kistkas in the last few years. The cost is from fifteen to thirty dollars. Some of the electric kistkas come with replacable tips (fine, medium and heavy) so that tips can be changed easily for making different widths of lines. The other kistkas are made with a stationary tip which makes a line of one thickness. In order to get heavier or finer lines, one must plug in another tool, wait a few minutes for it to heat and then continue. Both types of tools work extremely well, and for the experienced hand, they can speed up the process considerably. These marvelous inventions work much like the regular kistka. They melt the wax at an even heat which allows the beeswax to flow for a long period of time without filling.

One slight problem arises with their use, the beeswax will not turn black with this method since there is no carbon from the flame of the candle. It is difficult to see the wax lines on the egg since they are transparent. Here are a few easy ways to remedy this! Melt two ounces of beeswax in a clean tin can (slowly please) and add either a half piece of black crayon or a half teaspoon of black wax shoe polish, the kind bought in a little tin. This turns the wax black, and then it is easy to see on the egg while working. Another way is to simply place the beeswax in a clean can and heat it, slowly bringing it to a boil. The longer it boils the blacker it becomes. Caution should be taken always when working with melted wax. It is highly flammable. The melted wax may be poured from the tin can into a paper cup and allowed to cool. Later the paper cup is peeled off and there will be a cake of dark wax. This is strongly recommended for use with the electric kistka.

We use the electric kistka almost exclusively now since it saves much time and it is less likely to drip. Information on the electric kistka may also be obtained from the Ukrainian Gift shop.

Bibliography

Binyashevsky, Erast, *Ukrainian Pysanky*, Keiv, Ukraine, 1968
Coskey, Evelyn, *Easter Eggs for Everyone*, Abingdon Press, New York, 1973
Dustin, Virginia L., "Easter Eggs . . . A Ukrainian Folk Art", *The Palatte*,
 Volume 27, Number 2, Spring 1947
Glykenvand, Lily M., "Christ is Risen! — He is Risen Indeed!",
 Scope, April 1962
Hawryluk-Charney, Halia, "The Origin of Religious Easter Celebrations",
 Woman's World, Vol XIX, April 1968
Horniakevych, D., *Ukraine – A Concise Encyclopedia*, University of
 Toronto Press, Canada, 1963
Luciow, Theodore, "Easter Red Letter Day Of Year in Ukraine",
 Tacoma (Washington) *Sunday Ledger-News Tribune*,
 magazine section, April 22, 1962
Newall Venitia, *An Egg at Easter, A Folklore Study*, Indiana University
 Press, 1971
Siryj, Mrs. Wasyl, "How to Make a Pysanka", *Forum*, Volume 15,
 Number 4, Winter 1967-68, Scranton, Pennsylvania
Surmach, Yaroslava, *Ukrainian Easter Eggs*, Surma, 11 East 7th
 Street, New York, New York, 1957

Index